Earrings

LARK STUDIO SERIES

LARK CRAFTS

An Imprint of
Sterling Publishing Co., Inc.
New York

Library of Congress Cataloging-in-Publication Data

Lark studio series : earrings. -- 1st ed.
 p. cm.
 Includes index.
 ISBN 978-1-4547-0086-9 (pb-flexibound : alk. paper)
 1. Earrings--History--21st century--Catalogs. I. Title: Earrings.
 NK7423.5.L37 2011
 739.27'8--dc22

 2011007643

SENIOR EDITOR
Linda Kopp

EDITOR
Julie Hale

ART DIRECTOR
Kristi Pfeffer

LAYOUT
Matt Shay

COVER DESIGNER
Kristi Pfeffer

FRONT COVER
Luana Coonen
Morpho Encasements
PHOTO BY AMY O'CONNELL

BACK COVER
Leila Tai
Blue Iris Earrings
PHOTO BY RALPH GABRINER

PAGE 3
Rebecca Deans
Graduate
PHOTO BY BRIAN STEVENS

PAGE 4
Nina Basharova
*Milky Way Day and
Night Earrings*
PHOTO BY DYLAN CROSS

10 9 8 7 6 5 4 3 2 1

First Edition

Published by Lark Crafts, An Imprint of
Sterling Publishing Co., Inc.
387 Park Avenue South, New York, NY 10016

Text © 2011, Lark Crafts, an Imprint of Sterling Publishing Co., Inc.
Photography © 2011, Artist/Photographer

Distributed in Canada by Sterling Publishing,
c/o Canadian Manda Group, 165 Dufferin Street
Toronto, Ontario, Canada M6K 3H6

Distributed in the United Kingdom by GMC Distribution Services,
Castle Place, 166 High Street, Lewes, East Sussex, England BN7 1XU

Distributed in Australia by Capricorn Link (Australia) Pty Ltd.,
P.O. Box 704, Windsor, NSW 2756 Australia

If you have questions or comments about this book, please contact:
LARK CRAFTS | 67 Broadway | Asheville, NC 28801 | 828-253-0467

Manufactured in China

ISBN 13: 978-1-4547-0086-9

For information about special sales, contact the Sterling Special Sales Department at
800-805-5489 or **specialsales@sterlingpub.com**.

For information about desk and examination copies available to college and
university professors, requests must be submitted to academic@larkbooks.com.
Our complete policy can be found at www.larkcrafts.com.

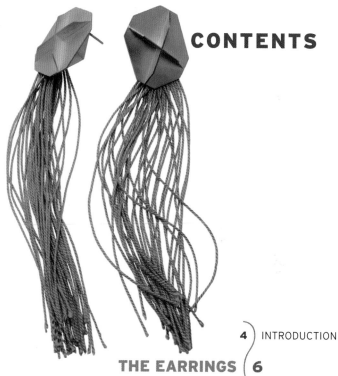

CONTENTS

4) INTRODUCTION

THE EARRINGS (**6**

202) ARTIST INDEX

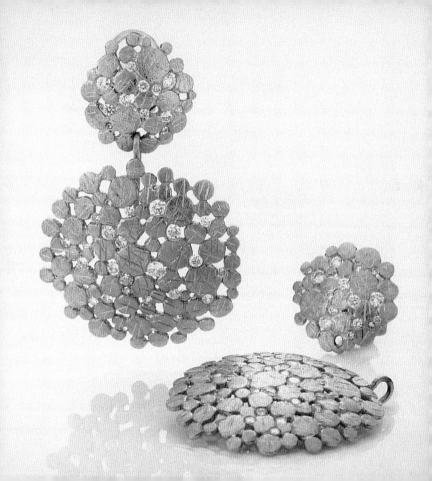

INTRODUCTION

The Lark Studio Series is designed to give you an insider's look at some of the most exciting work being made by artists today. The earrings we've selected represent a cross-section of superbly creative work being crafted for the pleasure of adornment. On this thrilling visual journey, you can expect the unexpected—earrings wrought from non-traditional materials such as rubber, chenille, and fur—but you'll also discover dazzling pieces made from precious metals and gems that epitomize tradition. Contributed by world-renowned jewelers, these works range from cutting edge to classic and reflect a variety of styles, approaches, and techniques. All are executed flawlessly to culminate in the ultimate personal expression.

Mary Preston

BOBBIN LACE EARRINGS
Each, 4.7 x 3.1 x 0.5 cm

18-karat gold, pana shell; hand fabricated

PHOTO BY ARTIST
COURTESY OF ORNAMENTUM GALLERY,
HUDSON, NEW YORK

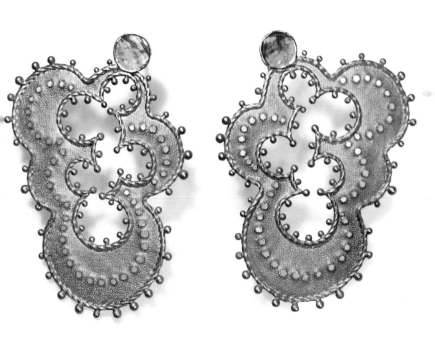

Jayne Redman

TULIP EARRINGS

Each, 4.2 x 2 x 2 cm

18-karat yellow gold, fine silver; hand fabricated,
kum boo, oxidized

PHOTO BY ROBERT DIAMANTE

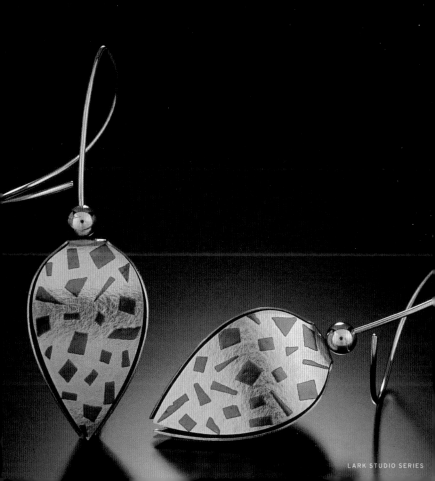

Christine Uemura

AVIAN MÉCANIQUE
Each, 7 x 3.2 x 0.5 cm

22-karat gold, sterling silver; hand fabricated, riveted

PHOTO BY GEORGE POST

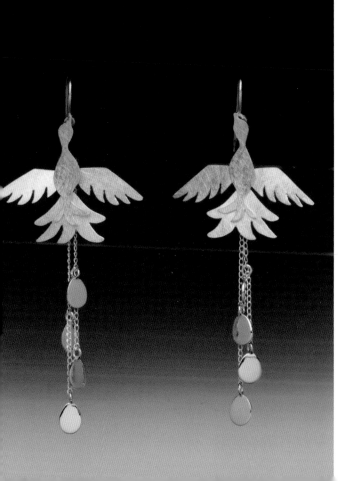

Terry Kovalcik

DANCING DANGLES
Each, 7 x 1 x 0.7 cm

Metal clay; hand fabricated, oxidized

PHOTO BY CORRIN KOVALCIK

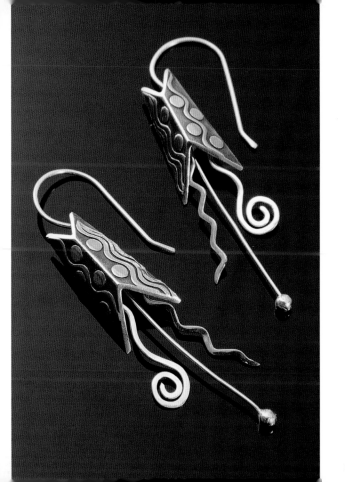

Klaus Spies

EBONY DISCUS EARRINGS

Each, 3.2 x 3.2 x 0.7 cm

Sterling silver, 18-karat gold, ebony; hand fabricated

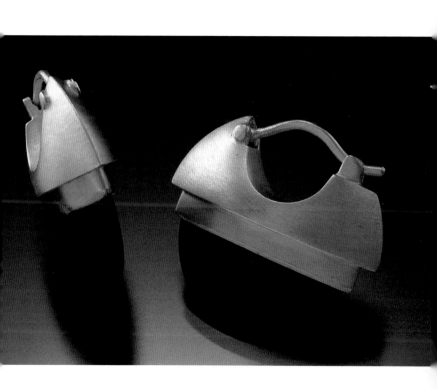

Barbara Heinrich

UNTITLED
Each, 3.3 x 1 x 1.5 cm

18-karat yellow gold, diamonds, pearls; pierced

PHOTO BY TIM CALLAHAN

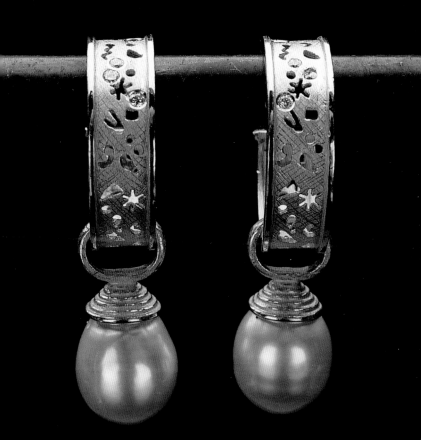

Nina Basharova

MILKY WAY DAY AND NIGHT EARRINGS
Each, 4.5 x 3.8 x 0.8 cm

18-karat gold, diamonds

PHOTO BY DYLAN CROSS

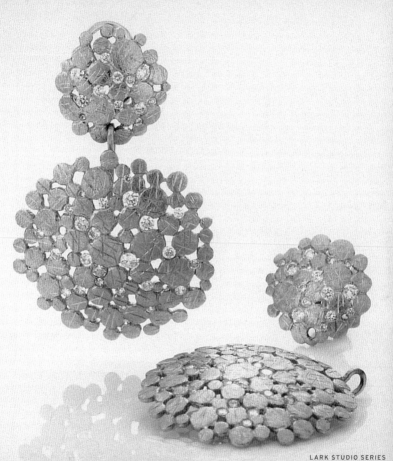

Hratch Babikian

SEAWEED DANGLE

Each, 6 x 1 x 0.5 cm

Sterling silver, 14-karat gold, garnet; fabricated,
forged, cast, buffed, textured

PHOTO BY ARTIST

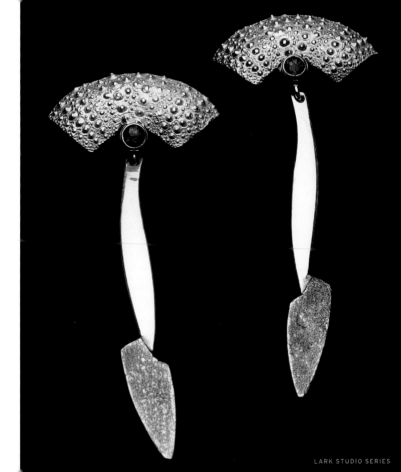

Rachelle Thiewes

SHIMMER
Each, 13.6 x 3.6 x 3.6 cm

18-karat palladium white gold, silver

PHOTO BY ARTIST

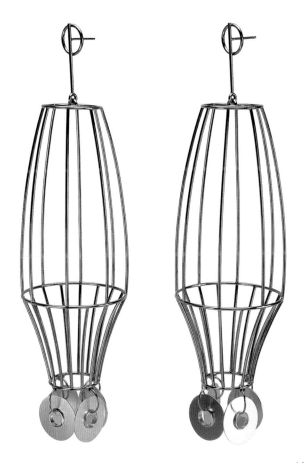

Munya Avigail Upin

HYPERBOLA PLUGS
Each, 4 x 4 x 3 cm

Silver, pearl, foam ear plugs; crocheted, fabricated

PHOTO BY ARTIST

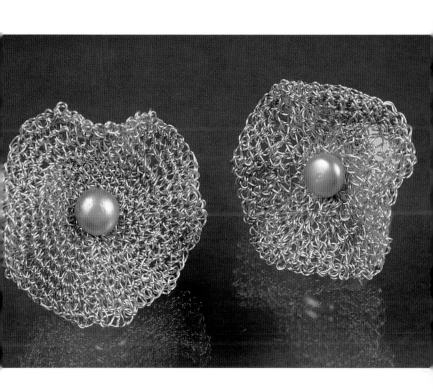

Jonathan Hernandez

BYE-BYE SUPERMAN SUITE

Each, 21 x 18 cm

Brass

PHOTO BY ROBLY GLOVER

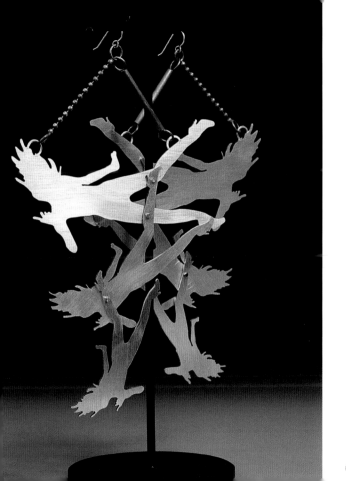

Carolyn Bensinger

LAST LEAF, FIRST SNOW

Each, 7 x 4 x 0.5 cm

Sterling silver, 18-karat gold, shakudo,
phantom jasper; formed, fabricated, oxidized

PHOTO BY DEAN POWELL

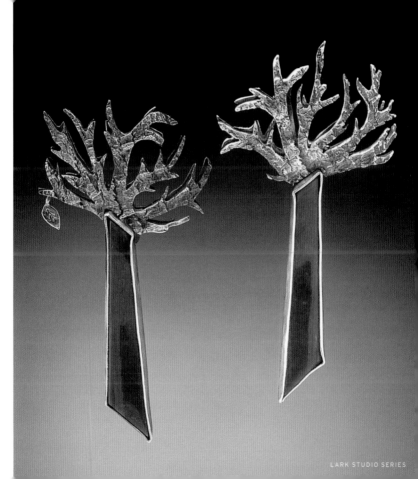

Birgit Kupke-Peyla

UNTITLED
Each, 3.4 x 3.4 x 0.4 cm

22-karat gold, sterling silver, white sapphire; hand fabricated,
roller printed, hammered, intarsia inlay, oxidized

PHOTO BY DAVID DRUEDING

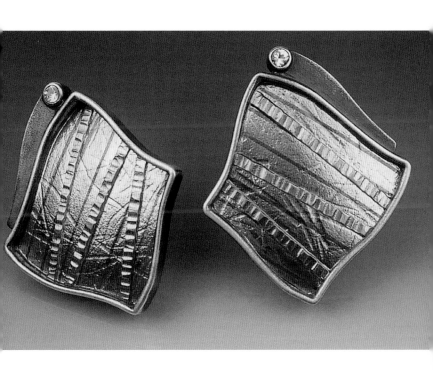

Joyce Goodman

FAN EARRINGS

Each, 4.5 x 4 x 0.3 cm

22-karat gold, 19-karat gold, sterling
silver, copper, patina; hand fabricated,
granulation, knitted, sewn

PHOTO BY RALPH GABRINER

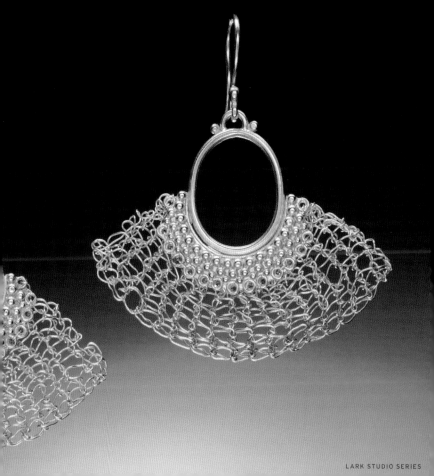

Rebecca Deans

GRADUATE
Each, 11.5 x 2 x 1.5 cm

Sterling silver, silk; hand fabricated

PHOTO BY BRIAN STEVENS

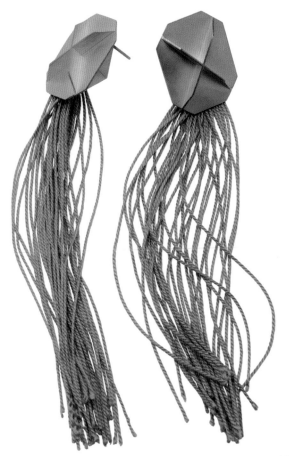

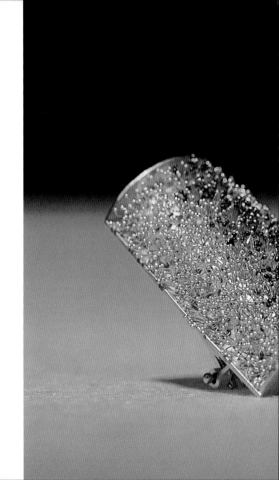

Giovanni Corvaja

UNTITLED
Each, 3 x 1.5 x 0.9 cm

22-karat gold; niello

PHOTO BY ARTIST

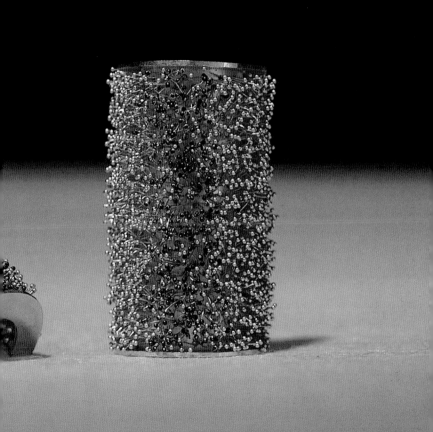

Jerry Scavezze

ORBITS
Each, 4 x 2 x 2 cm

18-karat gold, platinum, diamonds; anticlastic raising, fabricated

PHOTO BY RALPH GABRINER

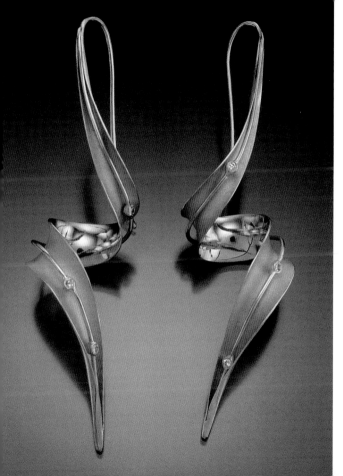

Eileen Gerstein

UNTITLED
Each, 2.5 x 3 x 0.5 cm

22-karat gold bimetal, sterling silver, 24-karat gold,
patina; hand fabricated, riveted, kum boo

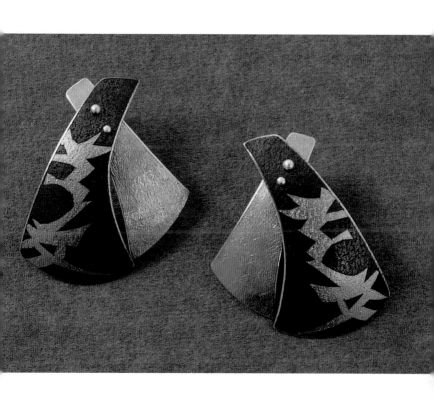

Sasha Samuels

BLACK AND WHITES
Each, 0.3 x 0.3 x 0.2 cm

22-karat gold, pearls, garnet; granulation

PHOTO BY DANIEL VAN ROSSEN

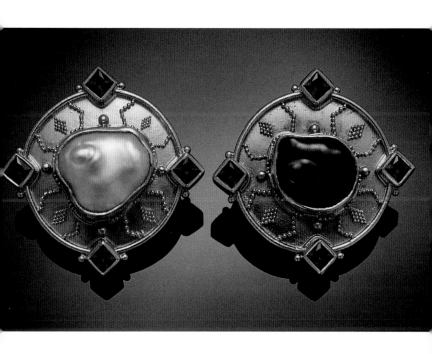

Brent R. Keeney

7 AND 7 IS…
SEVEN UNMATCHED EAR ORNAMENTS

Longest, 10 x 1.2 x 1 cm

14-karat white gold, 18-karat yellow gold,
diamonds, pearls; hand fabricated

PHOTO BY ARTIST

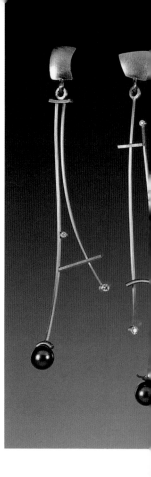

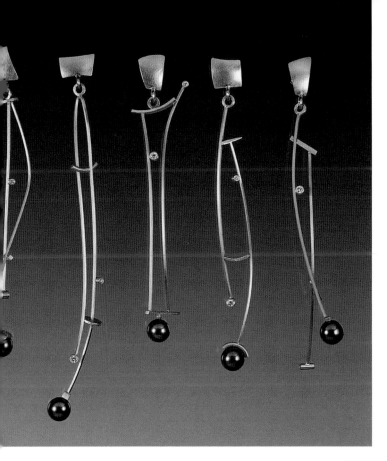

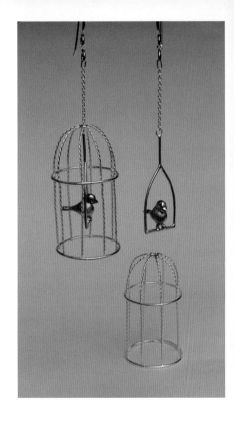

Cuyler Hovey-King

BIRD CAGE EARRINGS

Each, 7.9 x 2.2 x 2.2 cm

14-karat yellow gold, sterling silver;
wax carved, cast, fabricated

PHOTOS BY ARTIST

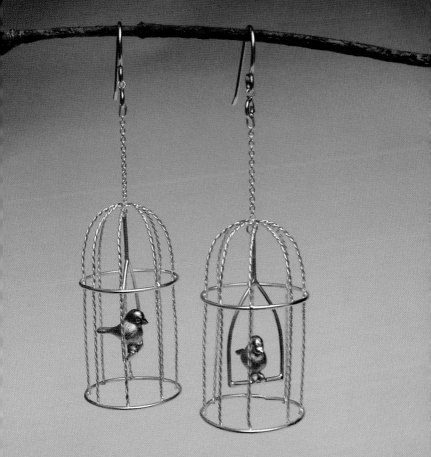

Dana Melnick

LIVE WIRE PEACE EARRINGS
5 x 4.5 x 0.1 cm

14-karat gold wire; heated, hand bent

PHOTO BY SANDRA RODGERS

Liaung-Chung Yen

UNTITLED
Each, 2 x 2 x 0.8 cm

18-karat gold, diamonds

PHOTO BY ARTIST

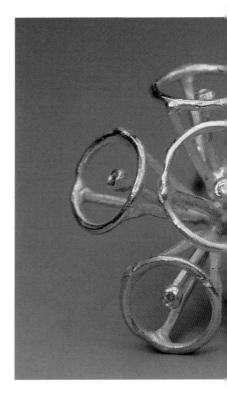

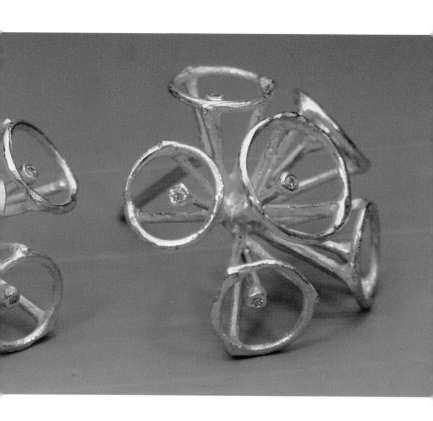

Kathy Kovel

LANTERN EARRINGS
Each, 5 x 1.2 x 1.2 cm

Sterling silver, 18-karat yellow gold, garnet; oxidized

PHOTO BY GEORGE POST

Kyle H. Leister

KITE EARRINGS
Each, 6.4 x 2.5 x 0.2 cm

Sterling silver, fine silver, copper,
 14-karat gold, pearls, patina; fabricated

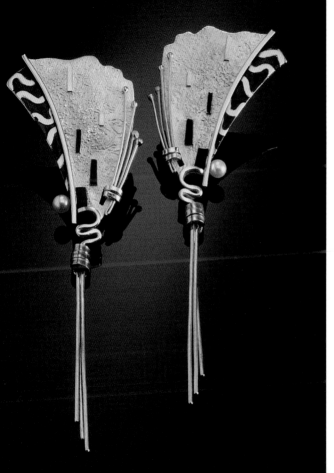

Belle Brooke Barer

BOAT EARRINGS

Each, 2.6 x 2.4 x 0.4 cm

18-karat yellow gold, sterling silver,
synthetic diamond; hand fabricated

Sarabeth Carnat

PINK PEARL PEA PODS

Each, 8.3 x 0.7 x 0.7 cm

18-karat gold, pearls; constructed

PHOTO BY CHARLES LEWTON-BRAIN

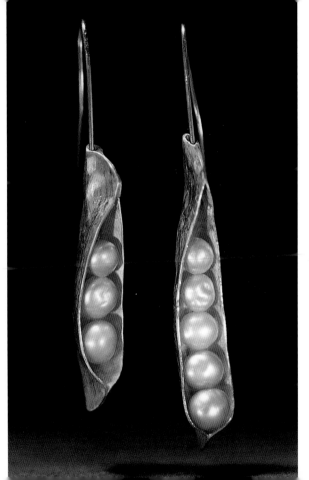

Tom Ferrero

GIRAFFE EARRINGS

Each, 7 x 2 x 2 cm

Fine silver, 18-karat gold, blue topaz,
patina; fabricated, kum boo

PHOTOS BY DAN NEUBURGER

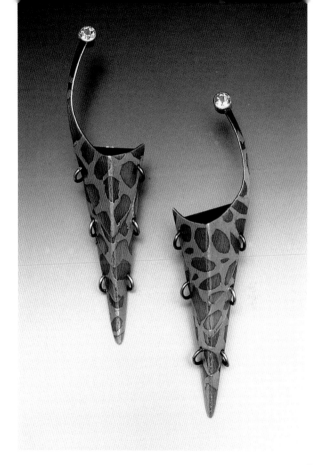

Noriko Sugawara

DREAMS
Each, 5 x 0.8 x 0.5 cm

24-karat gold, 18-karat gold, shakudo, diamonds,
Japanese patina; hand fabricated, inlay, cast

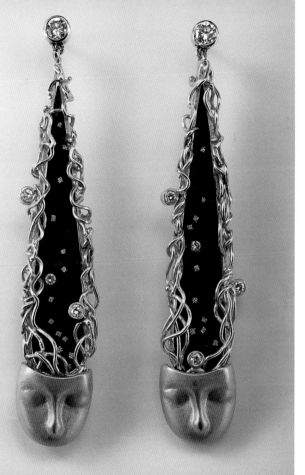

Todd Reed

UNTITLED

Each, 5.5 x 2 x 0.1 cm

18-karat yellow gold, sterling silver, patina,
raw diamonds, cut diamonds; hand forged, fabricated

PHOTO BY AZAD

Julia Turner

UNTITLED
Each, 8 x 1 x 1 cm

Ebony, 18-karat gold

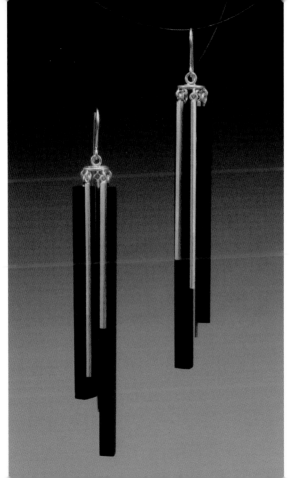

Christine Dhein

UNTITLED
7.5 x 4 x 1 cm

24-karat gold, sterling silver;
kum boo, roller printed, dapped

PHOTO BY ARTIST

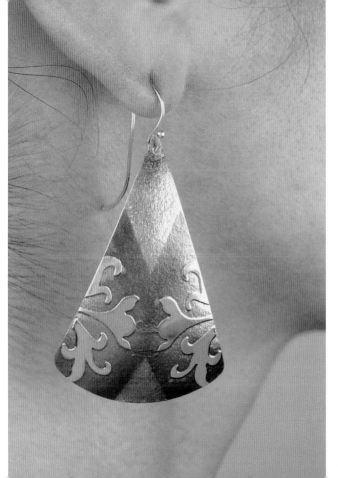

Hyeseung Shin

ONE DAY IN MY CHILDHOOD
Each, 5 x 3 x 1 cm

Sterling silver

PHOTO BY MUNCH

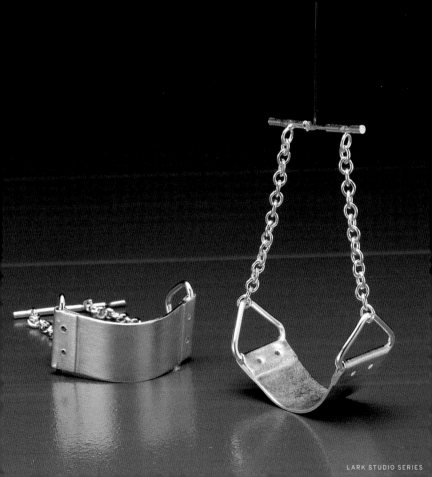

Angela Bubash

KINETIC EARRINGS
Each, 5 x 2.5 x 2.5 cm

Sterling silver, glass, dyed ostrich feathers; fabricated

PHOTO BY TOM MILLS

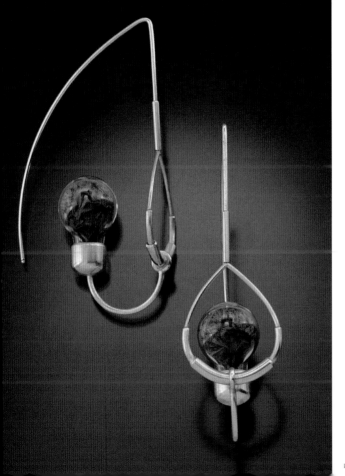

Babette Von Dohnanyi

WING EARRINGS
Each, 3 x 1.2 x 0.4 cm

Sterling silver, rose crystal, patina; cast

PHOTO BY FEDERICO CAVICCHIOLI

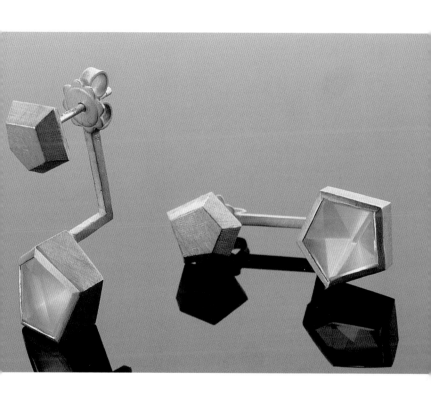

Adrienne M. Grafton

CHANDELIER EARRINGS
Each, 9 x 3 x 0.3 cm

Sterling silver, 14-karat gold; pierced, forged

PHOTO BY TOM MILLS

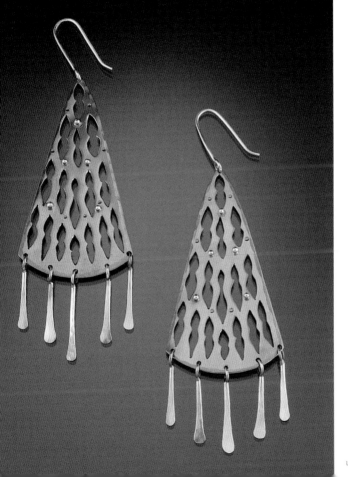

Stacy Petersen

CORAL EARPIECE
2 x 3 x 2 cm

Sterling silver; cast

PHOTO BY ARTIST

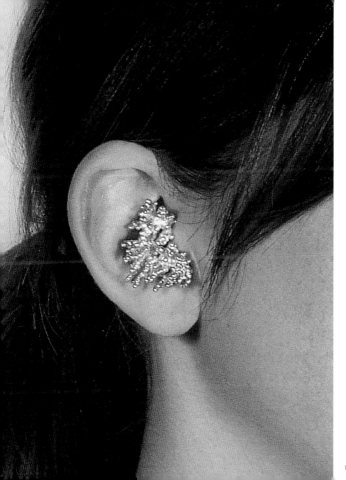

Jill Newbrook

UNTITLED
Each, 5.5 x 1 x 0.7 cm

18-karat white gold, silver, garnets

PHOTO BY JÖEL DEGEN

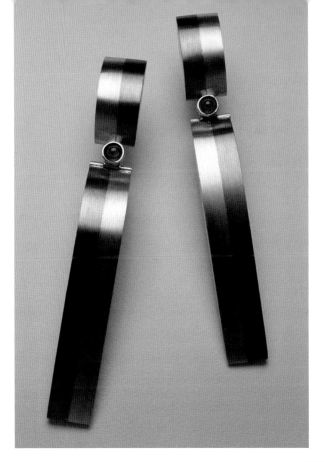

Mia Hebib

DAGNY TAGGART

Each, 6.7 x 2.8 x 0.1 cm

Sterling silver; fabricated

PHOTO BY ARTIST AND KEVIN GREVEMBERG

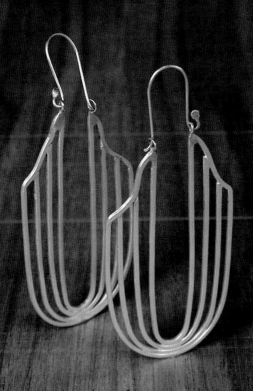

Julie Jerman-Melka

GENTLE CURRENT EARRINGS
Each, 4 x 1.2 x 0.6 cm

Beach pebble, sterling silver, 18-karat gold, aquamarines;
hand carved, forged, fabricated, tube set

PHOTO BY HAP SAKWA

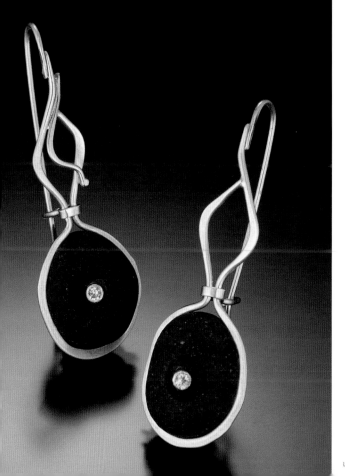

Birgit Laken

HEARTWEAR EARRINGS

Each, 4.5 x 4 x 0.4 cm

Silver; pressed, chased

PHOTO BY ARTIST

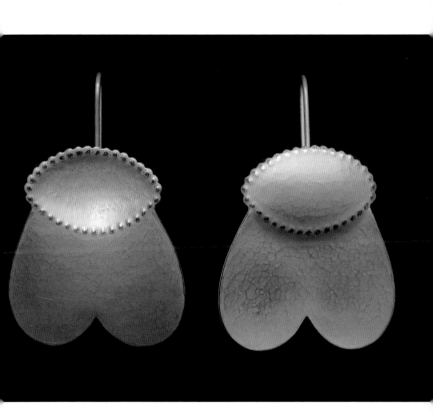

Mark Kanazawa

UNTITLED
Largest, 3 x 3.5 x 0.3 cm

Sterling silver, freshwater cultured pearls;
fabricated, cast, oxidized

PHOTO BY GUY NICOL

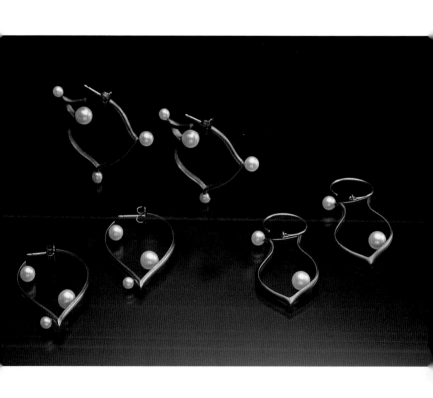

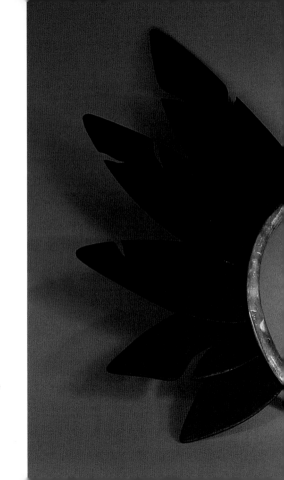

Kiren Niki Sangra

EAR WINGS
Each, 10 x 7 cm

Silver, aluminum; anodized,
hand fabricated, riveted

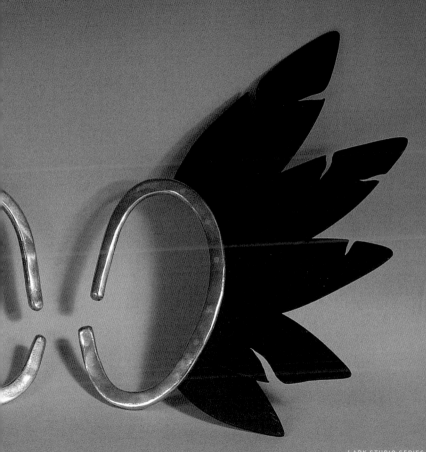

Eddie Sakamoto

BUBBLES

Each, 2.7 x 1.1 x 0.3 cm

18-karat gold, diamonds; cast, hand fabricated

PHOTO BY ARTIST

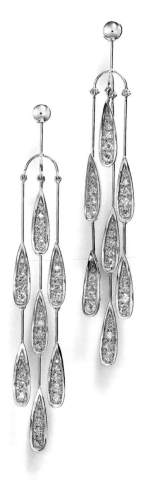

Rosemary Pham

BUTTON EARRINGS

Each, 1.3 x 1.3 x 0.7 cm

Sterling silver, embroidery floss; hand fabricated

PHOTO BY DOUG YAPLE
COURTESY OF FACÈRÈ JEWELRY ART GALLERY, SEATTLE, WASHINGTON

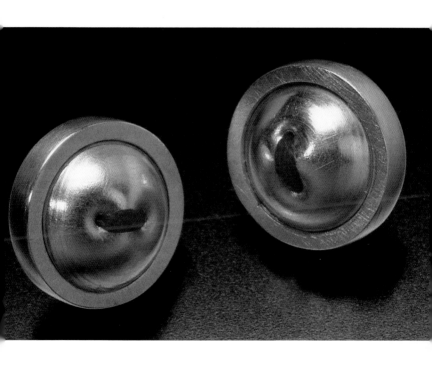

Kirsten Clausager

FLORA CON AMORE #3

Each, 9 x 3 x 3 cm

Sterling silver; oxidized, hand fabricated, bent, soldered, rolled

PHOTO BY OLE AKHOJ

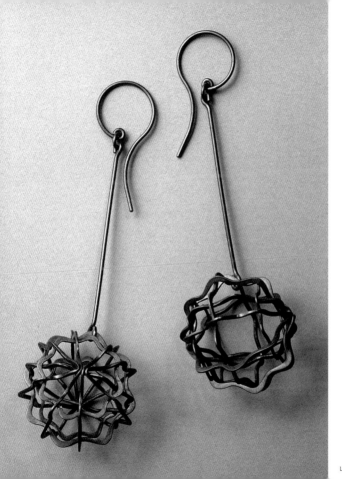

Vina Rust

EARRINGS #10: STAMEN SERIES
Each, 4.2 x 3.1 x 0.3 cm

Sterling silver, 22-karat gold, 14-karat gold,
patina; hand fabricated, oxidized

PHOTO BY DOUG YAPLE

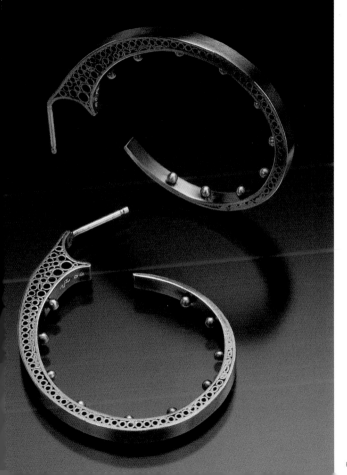

Hyejeong Ko

EARRINGS
Each, 8 x 3.5 x 3.5 cm

Sterling silver; hand fabricated

PHOTO BY DAN NEUBERGER

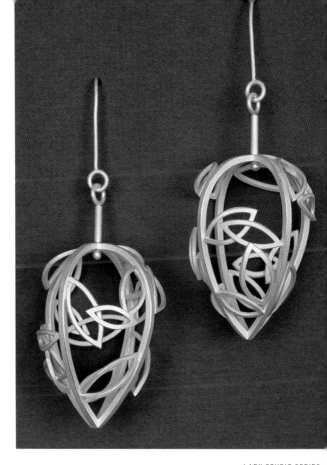

Amy Cannon

TRIPLE POINTS
Each, 4.5 x 0.8 x 0.4 cm

Sterling silver; riveted, matte finished, oxidized

PHOTO BY RICHARD WALKER

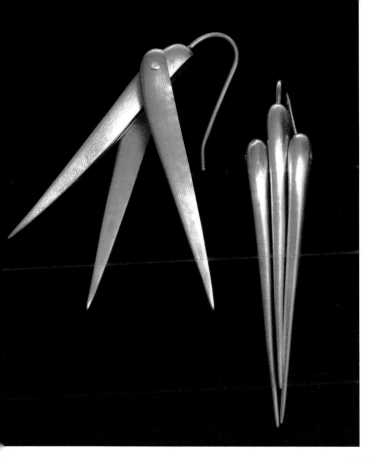

Cappy Counard

BILLOW EARRINGS
Each, 3.2 x 2.5 x 0.6 cm

18-karat gold, sterling silver, Tibetan turquoise,
patina; hand fabricated, scored, folded, etched

PHOTO BY ARTIST

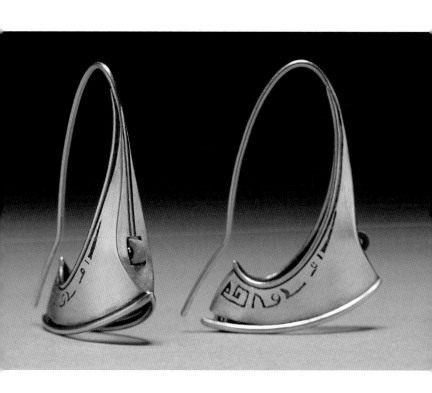

Paula Crespo

UNTITLED
12 x 6.5 cm

Sterling silver; hand fabricated, oxidized

PHOTO BY CATARINA CRESPO

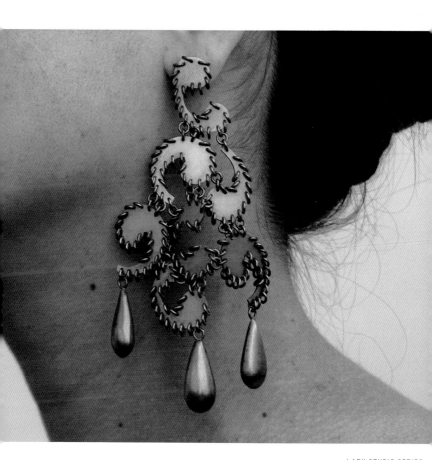

Patricia Zabreski Venaleck

DOTTED SWISS WINGS

Each, 2.5 x 0.8 x 0.5 cm

Glass, sterling silver; lampworked, forged, soldered

PHOTO BY JERRY ANTHONY

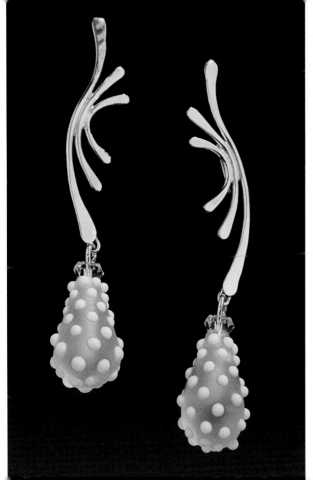

Bruce Anderson

E 88-3
Each, 4.5 x 2.5 x 0.6 cm

18-karat gold, sterling silver, lapis lazuli, sapphire

PHOTO BY RALPH GABRINER

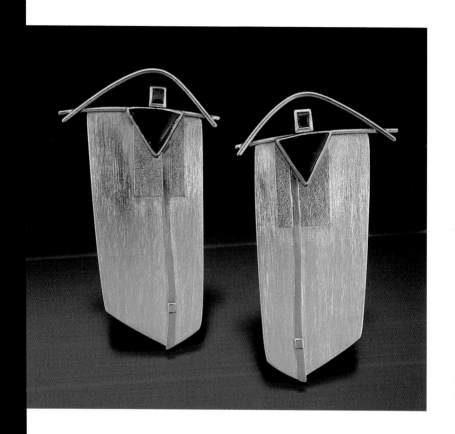

Claude Schmitz

MADELEINE
Each, 4.4 x 1.8 x 1.3 cm

18-karat gold, turquoise; hand fabricated

PHOTO BY WIM

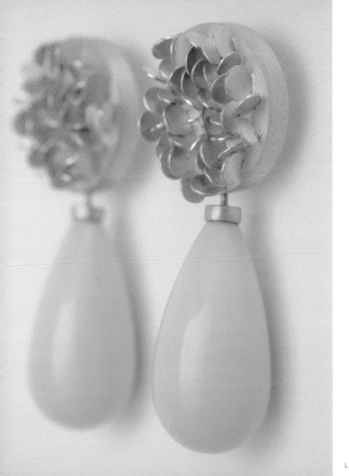

Beth Rosengard

NEON DUSTERS
Each, 4.7 x 1.4 x 0.5 cm

14-karat gold, 18-karat gold, 22-karat gold, apatite,
boulder opals; hand fabricated, broom cast

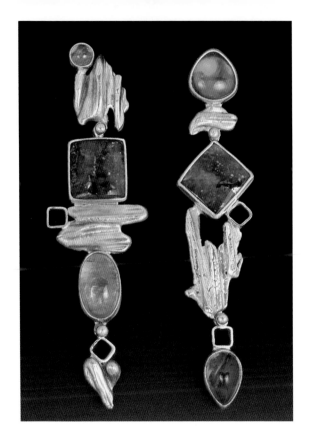

Tracy Johnson

UNTITLED
Each, 3.5 x 2 x 0.8 cm

18-karat gold, 22-karat gold, aquamarine,
 pink sapphire; hand fabricated, bezel set, hinged

PHOTO BY ROBERT DIAMANTE

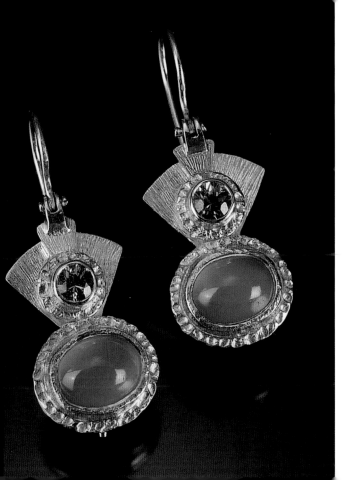

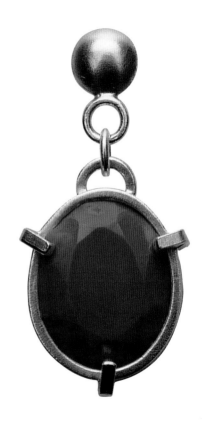

Cheryl Sills

UNTITLED
Each, 1.5 x 1 x 0.5 cm

Silver, rubber stones; cast

PHOTO BY STUDIO LA GONDA

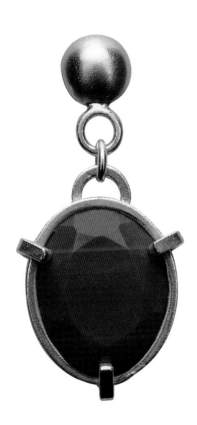

Loretta Fontaine

GRAVID SERIES–ETCHED SUNFLOWER EARRINGS
Each, 3.2 x 2.2 x 1 cm

22-karat gold, 14-karat gold, sterling silver, amethyst, opal, quartz drozy, freshwater pearls, black and white photographs, patina; hand fabricated, etched

PHOTO BY ARTIST

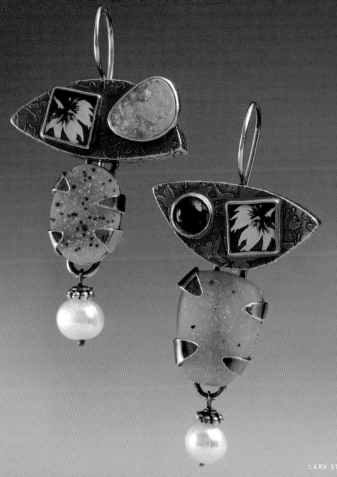

Janice Grzyb

KING AND QUEEN
Each, 6.4 x 1.9 x 0.6 cm

22-karat gold, 18-karat gold, precious and
semi-precious stones, pearl; hand fabricated

PHOTO BY RALPH GABRINER

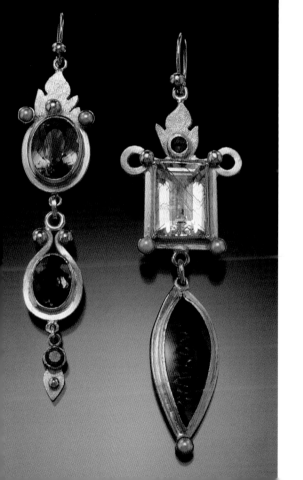

Barbara Bayne

THREE PAIRS OF COLLAGE EARRINGS
Largest, 2 x 2 x 0.5 cm

18-karat gold, sterling silver; die formed, hand fabricated, oxidized

PHOTO BY PAM PERUGI MARRACCINI

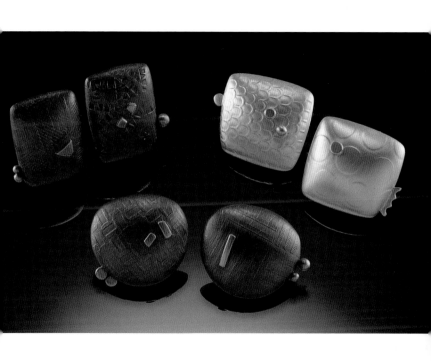

Diana Vincent

UNTITLED
Each, 2.9 x 1.6 cm

18-karat white gold, 18-karat yellow gold,
diamonds, pink tourmaline; hand fabricated

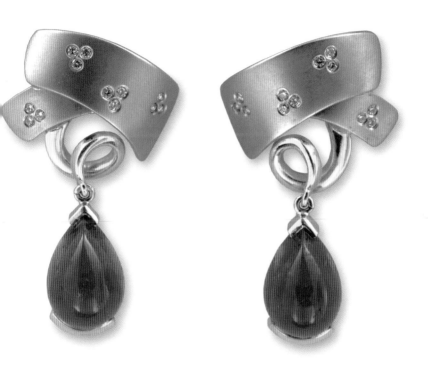

Leila Tai

BLUE IRIS EARRINGS
Each, 3 x 2.3 x 0.5 cm

18-karat gold, aquamarine, enamel;
hand fabricated, pierced, plique-à-jour

PHOTO BY RALPH GABRINER

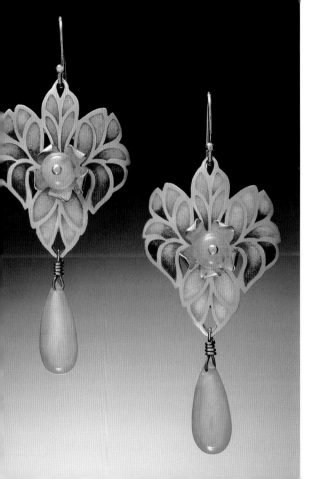

Thomas Herman

LAUREL LEAF HOOPS WITH BLACK TAHITIANS
Each, 2.7 x 1.3 x 1.3 cm

18-karat white gold, diamonds, pearls; carved, chased, pierced, inlay

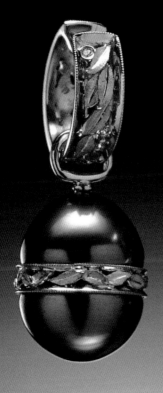
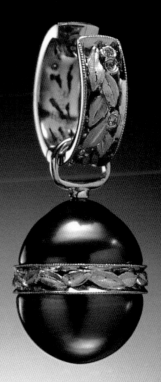

Lee Ramsey Haga

LIGHTNING OVER RIVER
Each, 3.7 x 1.7 x 0.5 cm

Shibuishi, sterling silver, 23-karat gold leaf,
variscite, patina; reticulated, hand fabricated

PHOTO BY PAUL YONCHEK
COURTESY OF CONTEMPORARY CRAFTS MUSEUM AND GALLERY, PORTLAND, OREGON

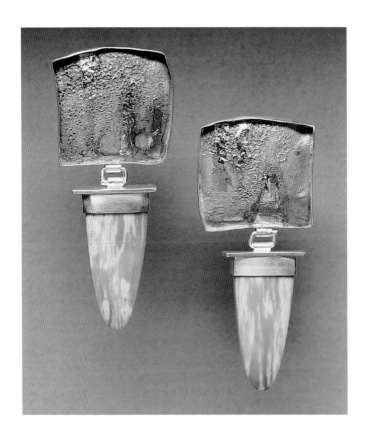

Luana Coonen

MORPHO ENCASEMENTS
Each, 5.1 x 5.1 x 0.6 cm

Sterling silver, acrylic, butterfly wings; cut, riveted, forged

PHOTO BY AMY O'CONNELL

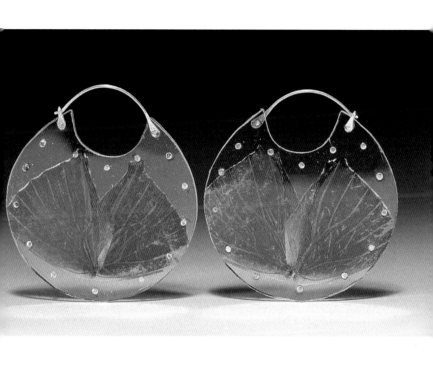

Cynthia Eid

BEE LINES
Each, 10 x 0.7 x 0.7 cm

18-karat yellow gold, sterling silver bimetal, sterling silver,
patina; micro-folded, fold formed, hand fabricated

PHOTO BY ARTIST
COURTESY OF MOBILIA GALLERY, CAMBRIDGE, MASSACHUSETTS

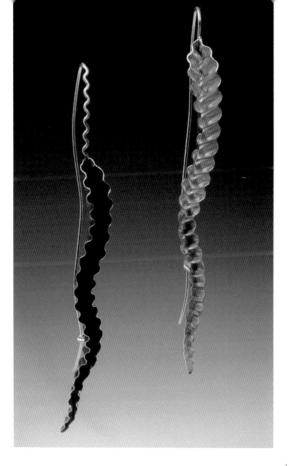

Vlad Lavrovsky
Cesar Lim

BLUE FROM THE SOGNI D'ORO COLLECTION
Each, 10 x 2.5 x 0.5 cm

Blue diamonds, blue zircon, fine silver, 18-karat yellow gold;
cast, hand fabricated, hammered, oxidized

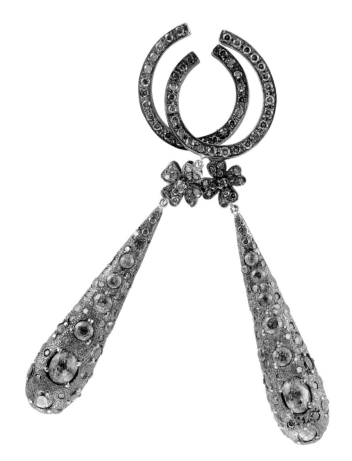

Octavia Cook

COOK AND CO. OCTOPUS EARRINGS
Each, 4.2 x 1.8 x 0.8 cm

Sterling silver, cut crystal; hand fabricated, oxidized

PHOTO BY STUDIO LA GONDA

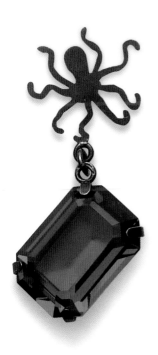
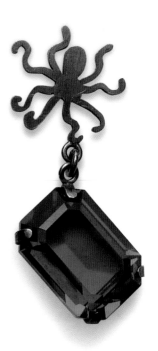

Françoise and Claude Chavent

COPEAUX
Each, 3.5 x 2.5 x 0.1 cm

Platinum, 22-karat gold; hand fabricated

Barbi Gossen

UNTITLED
Each, 6 x 2.5 x 2.5 cm

Gold, sterling silver, fine silver,
enamel; raised, sifted, cloisonné

PHOTO BY ARTIST

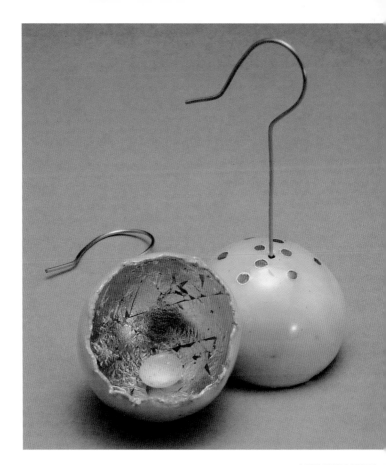

Jayne Redman

COLUMBINE EARRINGS

Each, 4.2 x 2 x 2 cm

18-karat yellow gold, 18-karat white gold,
sterling silver; hand fabricated, oxidized

PHOTO BY ROBERT DIAMANTE

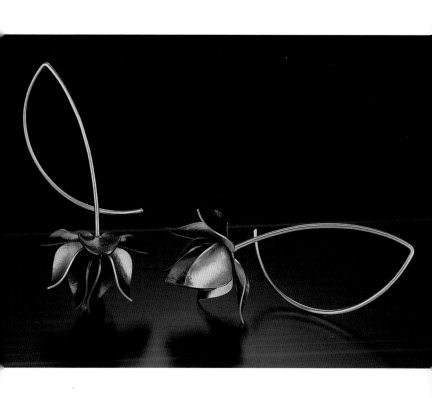

Daphne Krinos

UNTITLED
Each, 5.2 x 2 x 0.5 cm

Silver, rutilated quartz, diamonds; oxidized

PHOTO BY JOËL DEGEN

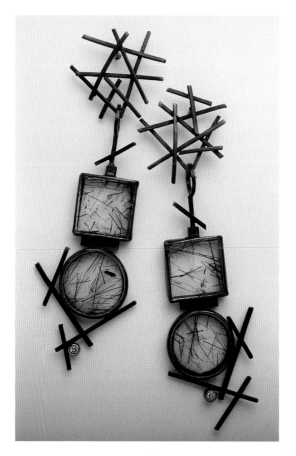

Heidi BigKnife

UNTITLED
Each, 7 x 1.3 x 1.3 cm

Sterling silver, thermoplastic, mailing labels, digital images
on paper; hand fabricated, bezel set, inkjet printed

PHOTO BY SCOTT MILLER

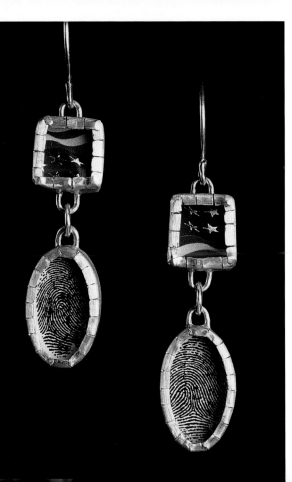

Kiwon Wang

JEWEL CONTAINER
Each, 7.6 x 2.5 x 2.5 cm

Sterling silver, newspaper, pearl, 23-karat gold leaf

PHOTO BY JAMES BEARDS

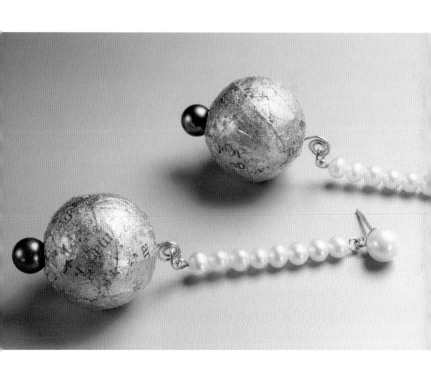

Jan Wehrens

EARRINGS
Each, 7 x 5.6 x 1.6 cm

Steel, vinyl

PHOTO BY ANGELA BRÖHAN

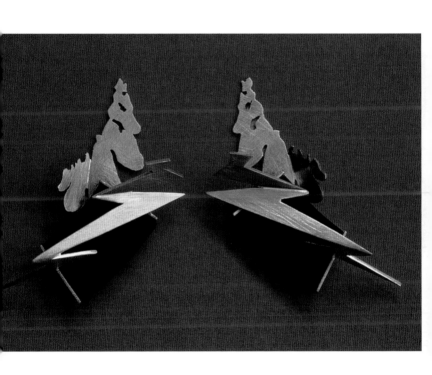

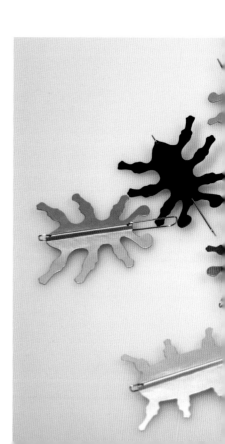

Beate Eismann

CHOCOLATE BEETLES
Largest, 7 x 4.7 x 1.2 cm

Aluminum, steel wire; sawed, anodized

PHOTO BY ARTIST

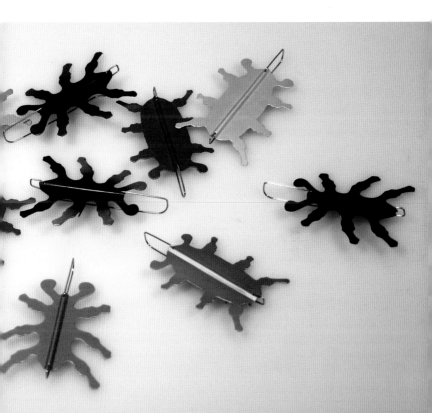

Marty Jestin

HEADSPIN?

Each, 0.4 x 1.3 x 1.2 cm

Automobile dashboard, acrylic, sterling silver,
18-karat gold; hand fabricated

PHOTO BY ARTIST

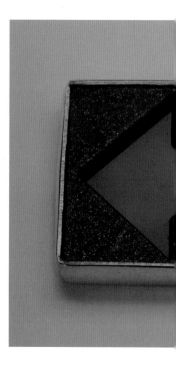

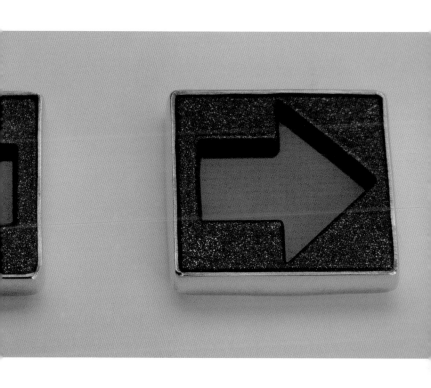

Jeffrey Kaphan

EARRINGS

Each, 6 x 2 cm

14-karat yellow gold, 14-karat white gold,
poppy jasper, pearls, fire opal; fabricated

PHOTO BY PERRY JOHNSON/IMAGICA

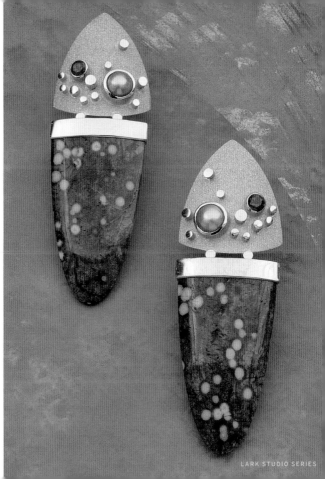

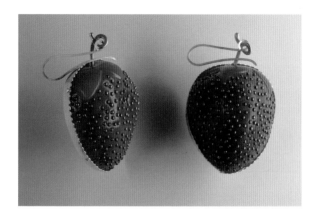

Jenna Wainwright

UNTITLED
Each, 6.7 x 4.6 x 2 cm

Silver, plastic toy, brass pins; cast, assembled

PHOTOS BY ARTIST

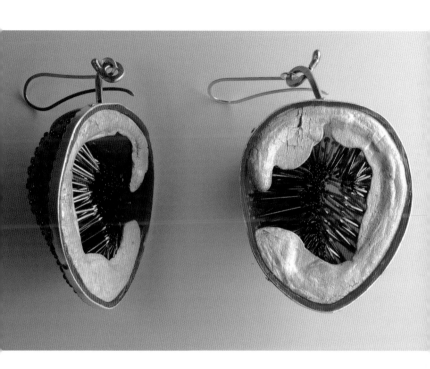

Ingeborg Vandamme

CONE EARRINGS
Each, 6.5 x 3.5 x 1.5 cm

Copper, paraffined paper

PHOTO BY ARTIST

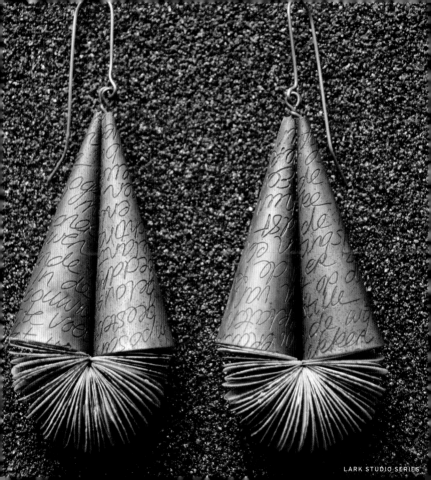

Sumner Silverman

UNTITLED

Each, 2 x 2 x 0.5 cm

24-karat gold, 22-karat gold, 18-karat gold, mammoth fossil ivory,
ruby, pearl, polymer clay; carved, fabricated

PHOTO BY DEAN POWELL
COURTESY OF SKYLIGHT JEWELERS, BOSTON, MASSACHUSETTS

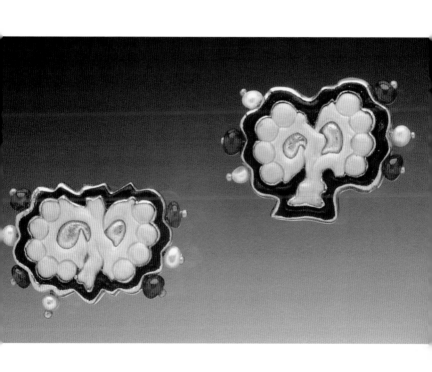

Julia M. Barello

SMALL FLOWERS
8 x 3.5 cm

Dyed x-ray film, monofilament; hand fabricated, heat treated

PHOTO BY MICHAEL O'NEILL

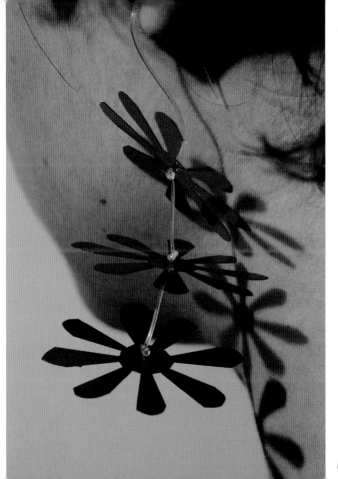

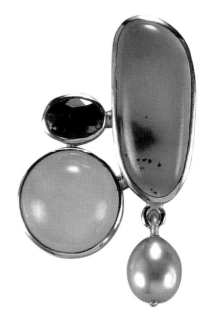

Janis Kerman

EARRINGS

Each, 3.5 x 2 cm

18-karat yellow gold, chrysoprase, iolite,
pearl, serpentine; hand fabricated

PHOTO BY DALE GOULD

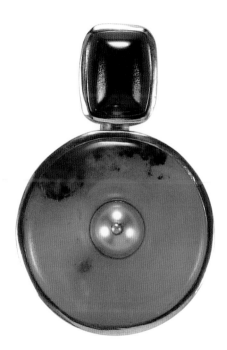

Christina Lemon

OCEAN SERIES EARRINGS
Each, 3 x 1.5 x 0.3 cm

Enamel, 14-karat gold, sterling silver; fabricated

PHOTO BY SETH TICE LEWIS

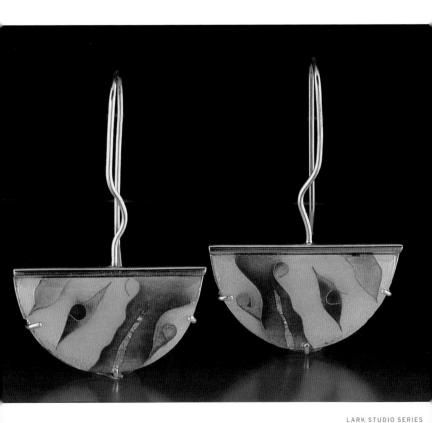

Hannah Louise Lamb

OVAL CURVE LEAF MISMATCH EARRINGS
Left, 4.5 x 2.5 x 0.1 cm

Silver; hand pierced, oxidized

PHOTO BY ARTIST

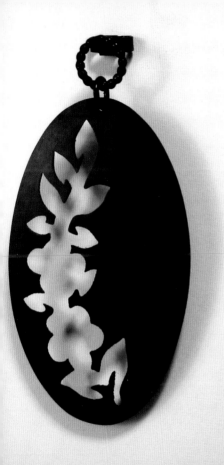
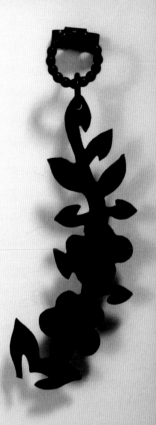

K.C. Calum

EARRINGS

Each, 12.5 x 12.5 x 3 cm

Wood, rubber, paint

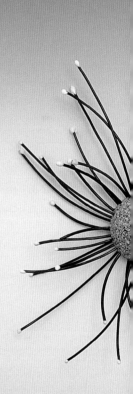

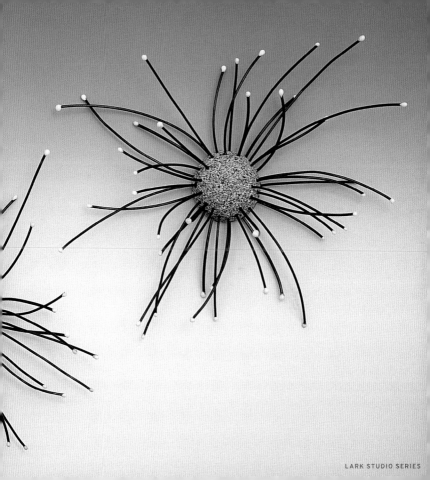

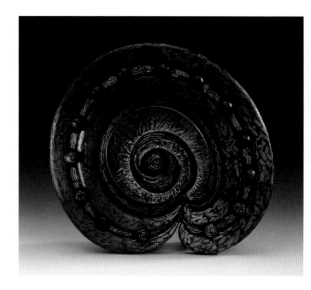

Marjorie Schick

SPIRAL EARRING FOR SPIRA GALAXY

Earring, 10.7 x 9.1 x 2.5 cm; on stand, 19.6 x 21.5 x 6.3 cm

Wood, paper-mâché, paint, wire; constructed

PHOTOS BY GARY POLLMILLER;
MODEL, KATHLENE ALLIE

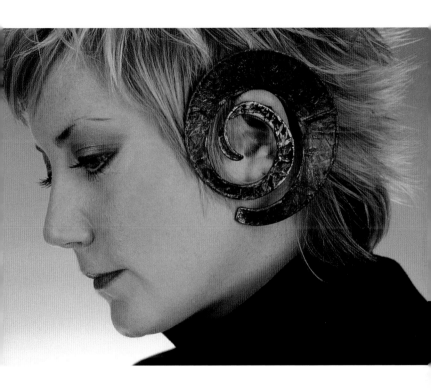

Micki Lippe

TWIG EARRINGS
Each, 5 x 5 x 1 cm

Sterling silver, pearls; hand fabricated, oxidized

PHOTO BY RICHARD NICOL

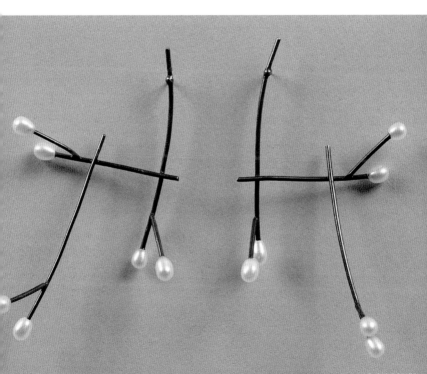

Shu-Lin Wu

REPRODUCTION
14.5 x 5 x 1.5 cm

Silver, resin

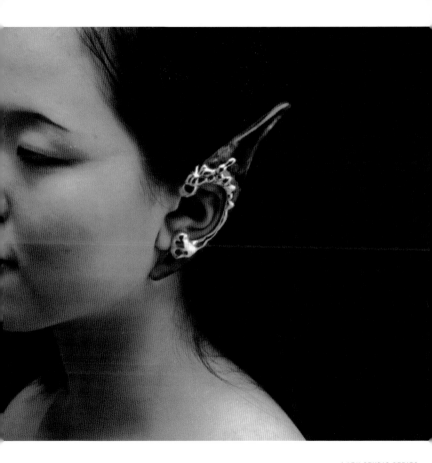

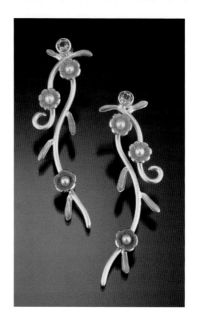

Giselle Kolb

EARRINGS

Box, 6 x 5 x 2.5 cm; earrings, 5 cm long

Sterling silver, fine silver, enamel, freshwater pearls,
blue topaz, resin; hand fabricated

PHOTOS BY HAP SAKWA

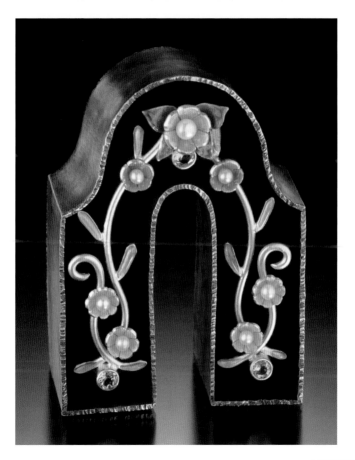

Kenneth MacBain

UNTITLED
Each, 6 x 5 x 0.5 cm

Steel nail, brass, mink fur; forged, textured, oxidized

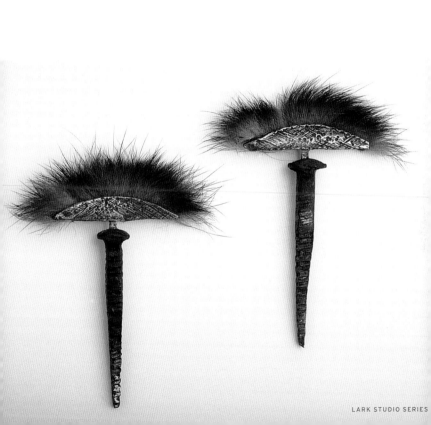

Polly Daeger

UNTITLED
Each, 7 x 1.5 x 1.5 cm

Copper; fold formed, cut, coiled

PHOTO BY LARRY SANDERS

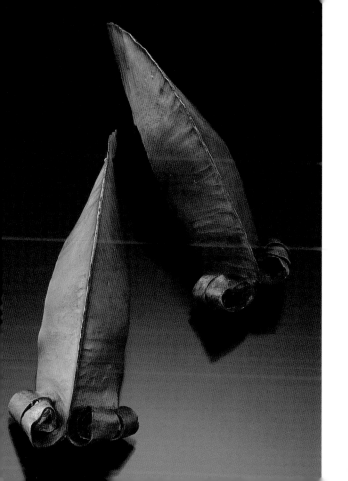

Azza Al Qubaisi

LIFE
Each, 2.2 x 0.6 cm

18-karat white gold, diamond;
hand fabricated, hammered

PHOTO BY ARTIST

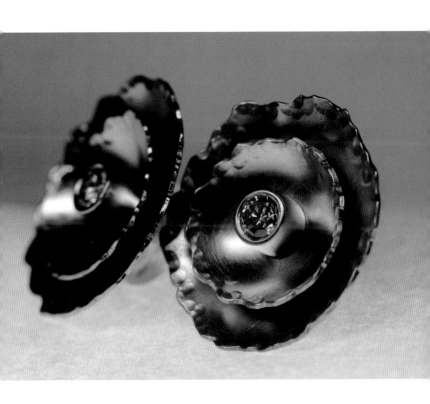

Sarah Penny

UNTITLED

Each, 7 x 2 x 1.5 cm

Sterling silver, 18-karat yellow gold;
hand fabricated, fold formed, depletion gilded

PHOTO BY ARTIST

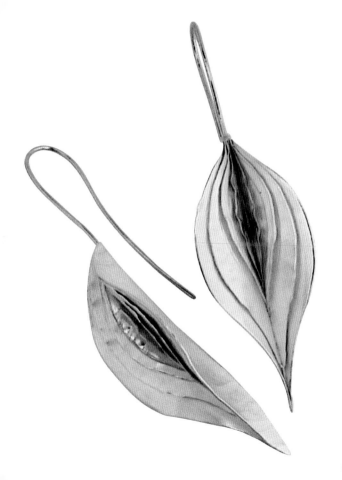

Yuka Saito

UNTITLED
12 x 4.5 x 4.5 cm

Recycled polypropylene, polyurethane, sterling silver

PHOTO BY ARTIST

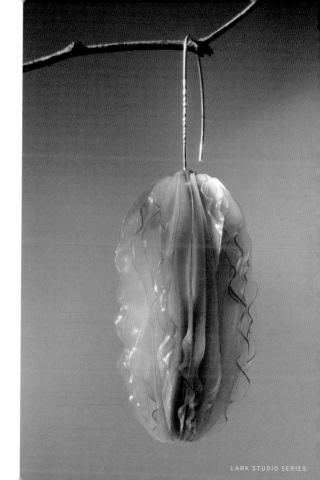

Daphne Krinos

UNTITLED
Largest, 6.5 x 1 x 1 cm

Silver, citrine, rock crystal; hand fabricated, oxidized

PHOTO BY JOËL DEGEN

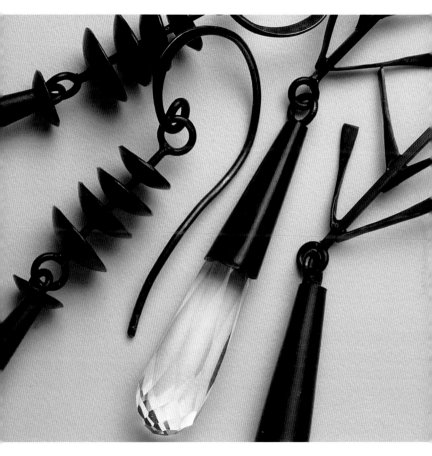

Donna E. Shimazu

ARTICULATED FLOWER CASCADE SERIES

Each, 5.4 x 1.3 cm

Shibuishi, 14-karat green gold, 14-karat yellow gold, patina;
cast, fabricated, riveted, engraved, torch painted

PHOTO BY JENNIFER CASTILLO

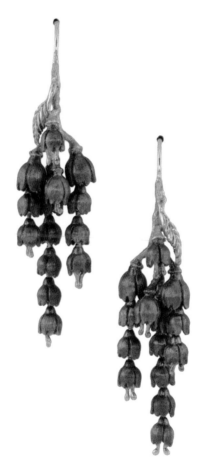

Caitlyn Davey

UNTITLED
Each, 9.5 x 9.5 x 2.5 cm

Recycled rubber, copper, enamel; 3-D modeled,
rapid prototyped, electroformed

PHOTO BY BILL BACHHUBER

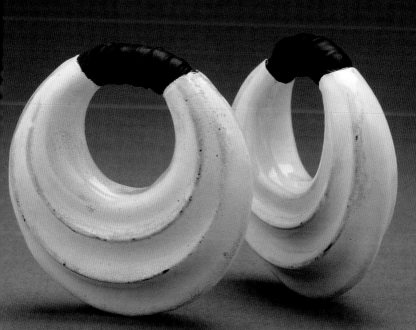

ARTIST INDEX

ANDERSON, BRUCE
Stanfordville, New York, 110

BABIKIAN, HRATCH
Philadelphia, Pennsylvania, 20

BARELLO, JULIA M.
Las Cruces, New Mexico, 168

BARER, BELLE BROOKE
Los Angeles, California, 56

BASHAROVA, NINA
New York, New York, 18

BAYNE, BARBARA
Havre De Grace, Maryland, 124

BENSINGER, CAROLYN
Watertown, Massachusetts, 28

BIGKNIFE, HEIDI
Tulsa, Oklahoma, 150

BUBASH, ANGELA
Spruce Pine, North Carolina, 72

CALUM, K.C.
Basking Ridge, New Jersey, 176

CANNON, AMY
Fly Creek, New York, 102

CARNAT, SARABETH
Calgary, Alberta, Canada, 58

CHAVENT, CLAUDE
Puilacher, France, 142

CHAVENT, FRANÇOISE
Puilacher, France, 142

CLAUSAGER, KIRSTEN
Vanløse, Denmark, 96

COOK, OCTAVIA
Kingsland, Auckland, New Zealand, 140

COONEN, LUANA
Haiku, Hawaii, 134

CORVAJA, GIOVANNI
Todi, Italy, 36

COUNARD, CAPPY
Edinboro, Pennsylvania, 104

CRESPO, PAULA
Lisbon, Portugal, 106

DAEGER, POLLY
Milwaukee, Wisconsin, 188

DAVEY, CAITLYN
Delhi, New York, 200

DEANS, REBECCA
San Francisco, California, 34

DHEIN, CHRISTINE
San Francisco, California, 68

DOHNANYI, BABETTE
Florence, Italy, 74

EID, CYNTHIA
Lexington, Massachusetts, 136

EISMANN, BEATE
Halle, Germany, 156

FERRERO, TOM
Windsor, Connecticut, 60

FONTAINE, LORETTA
Delma, New York, 120

GERSTEIN, EILEEN
San Rafael, California, 40

GOODMAN, JOYCE
New York, New York, 32

GOSSEN, BARBI
Green Bay, Wisconsin, 144

GRAFTON, ADRIENNE M.
Harmony, Pennsylvania, 76

GRZYB, JANICE
New York, New York, 122

HAGA, LEE RAMSEY
Portland, Oregon, 132

HEBIB, MIA
Brooklyn, New York, 82

HEINRICH, BARBARA
Pittsford, New York, 16

HERMAN, THOMAS
Stone Ridge, New York, 130

HERNANDEZ, JONATHAN
Littlefield, Texas, 26

HOVEY-KING, CUYLER
Atlanta, Georgia, 46

JERMAN-MELKA, JULIE
Fort Collins, Colorado, 84

JESTIN, MARTY
Palmerston North, New Zealand, 158

JOHNSON, TRACY
Harpswell, Maine, 116

KANAZAWA, MARK
Chicago, Illinois, 88

KAPHAN, JEFFREY
Jackson, Wyoming, 160

KEENEY, BRENT R.
Juneau, Alaska, 44

KERMAN, JANIS
Westmount, Quebec, Canada, 170

KO, HYEJEONG
Songpagu, Seoul, South Korea, 100

KOLB, GISELLE
Laurel, Maryland, 184

KOVALCIK, TERRY
Haledon, New Jersey, 12

KOVEL, KATHY
Oakland, California, 52

KRINOS, DAPHNE
London, England, 148, 196

KUPKE-PEYLA, BIRGIT
Salinas, California, 30

LAKEN, BIRGIT
Haarlem, Netherlands, 86

LAMB, HANNAH LOUISE
Leith, Edinburgh, Scotland, 174

LAVROVSKY, VLAD
Beverly Hills, California, 138

LEISTER, KYLE H.
Staunton, Virginia, 54

LEMON, CHRISTINA
Statesboro, Georgia, 172

LIM, CESAR
Beverly Hills, California, 138

LIPPE, MICKI
Seattle, Washington, 180

MACBAIN, KENNETH
Morristown, New Jersey, 186

MELNICK, DANA
Middletown, New Jersey, 48

NEWBROOK, JILL
London, England, 80

PENNY, SARAH
Toronto, Ontario, Canada, 192

PETERSEN, STACY
Boston, Massachusetts, 78

PHAM, ROSEMARY
Seattle, Washington, 94

PRESTON, MARY
Mamaroneck, New York, 6

QUBAISI, AZZA AL
Abu Dhabi, United Arab Emirates, 190

REDMAN, JAYNE
Portland, Maine, 8, 146

REED, TODD
Boulder, Colorado, 64

ROSENGARD, BETH
Los Angeles, California, 114

RUST, VINA
Seattle, Washington, 98

SAITO, YUKA
New York, New York, 194

SAKAMOTO, EDDIE
Torrance, California, 92

SAMUELS, SASHA
Portland, Oregon, 42

SANGRA, KIREN NIKI
Grande Prairie, Alberta, Canada, 90

SCAVEZZE, JERRY
Salida, Colorado, 38

SCHICK, MARJORIE
Pittsburg, Kansas, 178

SCHMITZ, CLAUDE
Luxembourg, Europe, 112

SHIMAZU, DONNA E.
Kailua, Hawaii, 198

SHIN, HYESEUNG
Chicago, Illinois, 70

SILLS, CHERYL
Kingsland, Auckland, New Zealand, 118

SILVERMAN, SUMNER
Tisbury, Massachusetts, 166

SPIES, KLAUS
Asheville, North Carolina, 14

SUGAWARA, NORIKO
New York, New York, 62

TAI, LEILA
New York, New York, 128

THIEWES, RACHELLE
El Paso, Texas, 22

TURNER, JULIA
San Francisco, California, 66

UEMURA, CHRISTINE
Pacheco, California, 10

UPIN, MUNYA AVIGAIL
Belmont, Massachusetts, 24

VANDAMME, INGEBORG
Amsterdam, Netherlands, 164

VENALECK, PATRICIA ZABRESKI
Macomb, Michigan, 108

VINCENT, DIANA
Washington Crossing, Pennsylvania, 126

WAINWRIGHT, JENNA
New York, New York, 162

WANG, KIWON
New York, New York, 152

WEHRENS, JAN
Munich, Germany, 154

WU, SHU-LIN
Taipei, Taiwan, 182

YEN, LIAUNG-CHUNG
Henrietta, New York, 50

Enjoy more of the books in the
LARK STUDIO SERIES

Ceramic Sculptures

Handmade Dolls

Art Tiles

Handmade Books

Tables

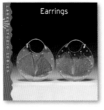
Earrings

Chairs

Pendants